COLOR PERCEPTION IN ART

BY FABER BIRREN

Schiffer Publishing Ltd

West Chester Pennsylvania

ACKNOWLEDGMENTS

Thanks are expressed to Wendy Lochner for her editing of this book. And to Shirley Riffe for her able and skillful help in executing most of the illustrations.

Library of Congress Cataloging in Publication Data

Birren, Faber, 1900-
 Color perception in art.

 Bibliography: p.
 Includes index.
 1. Color in art. 2. Color—Psychology.
3. Visual perception. I. Title.

Printed in the United States of America.
ISBN: 0-88740-064-7
Published by Schiffer Publishing Ltd.
1469 Morstein Road, West Chester, Pennsylvania 19380

This book may be purchased from the publisher.
Please include $1.50 postage.
Try your bookstore first.

CONTENTS

BY WAY OF INTRODUCTION
How the principles of this book and the Color Studies came into being

I have long felt that a new era of expression lies ahead for artists, designers, and all who seek that which is original and compelling in color. I will review in this book the great movements in color, from Turner to Impressionism, Neo-Impressionism, Fauvism, and Op Art—also emphasizing some low points, such as Abstract Expressionism, during which the art of color largely went into hibernation. I have always had faith and confidence that a still newer and more dramatic realm of color could be reached. And this persuasion will be found in the pages herewith.

Perception (over and above vision by itself) is one of the most vital fields of inquiry in the modern study of color. As will be seen, a knowledge of the mysteries of perception can and probably will lead to an art of color that breaks with and surpasses the schools and movements of the past.

One of the first steps in this direction was taken by Gestalt psychology, which was intimately concerned with perception, in the work of such men as Kurt Koffka, Wolfgang Köhler, Max Wertheimer, Ewald Hering, and, of particular and exciting promise, *The World of Color* by David Katz (1935). The Katz book was and still remains one of the foremost revealing sources of data on color and perception ever written. The work of Katz and others led me to formulate principles of color expression which I believe are new to

the art—and which are described and illustrated in both black and white and full color in this book.

Books related to psychology and perception were also published in America by Edwin G. Boring, Ralph Evans, James J. Gibson, Kurt Goldstein, R. L. Gregory, James P. C. Southall, M. D. Vernon, Heinz Werner, and others. Each of these offers new revelations of the intricacies of human perception, which can be translated into aesthetic terms and used to present, graphically, new modes of color statement.

In 1938 one of my major books appeared, *Monument to Color*. It was impressive in size, 9 × 12 inches, and was accompanied by 16 full-page plates, some printed in as many as 10 colors. The interest it aroused gave me enough encouragement to continue my investigation of visual effects such as luminosity, luster, iridescence—and pigments (printing inks) that could convey the appearance of chromatic light.

Meanwhile I planned other ventures and activities. In 1948 an exhibit was held at the National Arts Club in New York City in which a series of abstract color studies in oil (about 30), accompanied by a full-color catalog, was exposed to the art world. The exhibit then went to the Art Institute of Chicago and the Kansas City Art Museum, as well as to lesser galleries. (These particular oils are now in the possession of Yale University.)

In 1961 one of my most popular and successful textbooks on color appeared, *Creative Color*. (It eventually ran into several printings and was translated into German by a Swiss publisher in 1971.) *Color, Form and Space* was also published in 1961; it dealt with color in three-dimensional terms. Both these works continued to feature perceptual color effects derived from technical inquiries into visual and neural phenomena.

With the decline of Abstract Expressionism and the rise of Op Art, a key work by Josef Albers appeared in 1963, *Interaction of Color*. This became a milestone in the long history of color expression and greatly influenced modern modes and schools of art.

In 1965 another major work of mine was issued, *History of Color in Painting*, also on a large scale—372 pages, 9 × 12 inches, 100,000 words, over 500 illustrations, many in color. This book reviewed the story of color expression in art from the Renaissance to the present. My views on new perceptual theories were obviously included.

In 1967 a second public exhibit was held in New York City at the East Hampton Gallery. New studies were put on display. In 1969 a small, compact textbook was published, *Principles of Color*. It was part of a series which included works by Munsell and Ostwald, edited by myself.* Since then I have spent a good part of my time preparing this book and designing the color studies exhibited herein. Fortunately, discipline is back. I am convinced that what has recently been learned about the phenomena of *vision* and *optics* will stimulate exploration into the more personal and exciting phenomena of neural *perception*.

<div style="text-align: right">FABER BIRREN</div>

*See the complete list of books written and edited by Faber Birren.

FROM TURNER TO TOMORROW
The development of twentieth-century color expression

In this chapter I shall review the major color schools and movements in the nineteenth and twentieth centuries, skipping the old masters of previous generations. The story can be told in the accomplishments of individual artists who typified their eras and were innovators in them.

To me there is little doubt that Joseph Mallory Turner (1775–1851) was one of the greatest colorists of all time (see Illustration 1). What he achieved with the spectrum markedly influenced most color and art forms that followed, right up to the present day. Turner, in my opinion, had better foresight (and insight) into the new perceptionism which this book seeks to foster than any of the more recent Impressionists, Neo-Impressionists, Post-Impressionists, Expressionists, Fauvists, Orphists, or Synchromists, all of whom prided themselves on their color aptitude.

Turner was a unique, original, and independent thinker in the history of color in art. No good biography of his life exists: he lived mostly by himself, never married, and had prodigious energy and fantastic memory and imagination. He was precocious and was able to sell drawings at the age of 10. Unlike many artists, he never had trouble making a living and eventually died a wealthy man.

He was inspired by the work of Claude Lorrain, who created exceptionally luminous effects, mostly of sunsets. Because Turner lived in a day when paintings had to say something (abstractionism was unknown), he indulged in storytelling, history, mythology. Although many of these romantic works were carefully and adroitly executed, often in dark and somber hues, they contributed little to his later fame.

In time he became impatient with technique and frequently did watercolors and oils as if on furious impulse, frequently casting them aside in his studio and allowing a leaky roof to dribble water on them. Few painters were more violently criticized. He was accused of flinging paint pots in the face of the public, of executing his art as if with soapsuds, poached eggs, and spinach. His compatriot, Constable, wrote: "Turner has outdone himself; he seems to paint with tinted steam, so evanescent and so airy. The public thinks he is laughing at them, so they laugh at him in return."

However, criticism did not bother Turner. Color held such total fascination that he more or less abandoned himself to it. He achieved a luminosity with color never before attained. How? By letting pure, clean tints blend with subtle grays, a device that went over and beyond Impressionism into modern concepts of perceptionism in art. He was known to work within a few inches of his canvas, mix his colors together freely in a confused mass of streaks and daubs, and then walk away without looking back. In this he anticipated the fascination of Impressionists and Neo-Impressionists with additive and optical color mixtures.

He was an earnest student of color (reader, please note!). He was familiar with the color monograph of Moses Harris (c.1766), a theorist and engraver who gave the world the first example of a printed color circle in full hue. He read and annotated Goethe's treatise, *Farbenlehre*, and painted compositions based on Goethe's theories. He was a true precursor not only of a new vision of color based on the mysteries of perception but of abstract painting itself.

France was most influential in art during the latter decades of the nineteenth century and held this supremacy up to modern times. Turner was a lone English genius and a school of color unto himself; in France Impressionism came into being, broke sharply with the past, and established itself as one of the most dynamic and creative of all art and color movements.

In my opinion Impressionism began with two prominent men, Eugène Delacroix (1798–1863), a painter, and M. E. Chevreul, one of the world's most revered color theorists.

Delacroix was a brilliant man, cultured, intellectual, a leading artist, and acquainted with other greats of his day, such as Victor Hugo, Stendhal, Theophile Gautier, Alexandre Dumas, Baudelaire, George Sand, and Chopin. Many of the later Impressionists were from the middle class. Monet, for example, was the son of a grocer; Renoir, the son of a tailor; Pissarro was poor always.

Delacroix was a romantic. He took delight in color and in irritating the sober academicians of Paris. He was quite aware of the brilliant work of Turner (and Constable) and wrote highly of Turner. His *Journal* is replete with remarkable insights and references to color, but what he wrote was more exuberant than what he actually did with color on his canvases. (Illustration 2 shows one of his most famous paintings, *Massacre at Scio.*)

The budding Impressionists worshipped Delacroix, peeked into his studio, went to see the free color expression of his murals. He granted Manet permission to copy one of his paintings. Later van Gogh also copied Delacroix and wrote to his brother, Theo, that he ardently struggled to understand Delacroix.

He worked with broken tones of color, a later feature of Impressionism. He observed natural phenomena with a discerning eye. To Delacroix, "The enemy of all color is gray. . . . Banish all the earth colors." Color was alive, ever-changing in nature, shifting in subtlety from moment to moment. These views would indeed be the incentives of Impressionism.

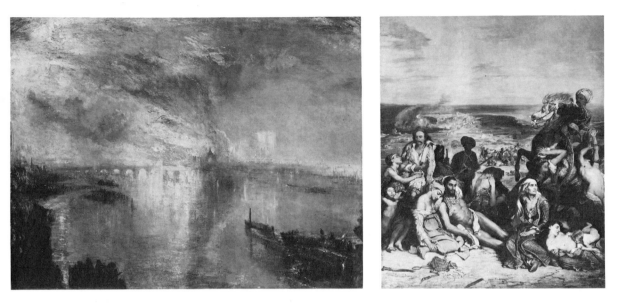

1. J. M. W. Turner, *Burning of the Houses of Parliament.* He was one of the most inventive of colorists. (Photo, The Cleveland Museum of Art, John L. Severance Collection.)

2. Eugène Delacroix, *Les Massacres de Scio.* He was greatly admired by the Impressionists for his devotion to color. (The Louvre, photo by Giraudon.)

The *Journal* of Delacroix includes the classical statement, "Give me mud, and I will make the skin of Venus out of it, if you will allow me to surround it as I please."

This introduces another eminent Frenchman, M. E. Chevreul (1786-1889), who wrote one of the greatest books on color, *The Principles of Harmony and Contrast of Colors.* This appeared in 1839. Delacroix, who was about 41 at the time, read the work avidly and passed his enthusiasm on to younger men. He made copious notes on Chevreul, who wrote clearly and extensively about simultaneous and alternate contrast, the laws of color *harmony*, and *visual* mixtures of color, a new and fresh venture in the technique of painting.

Chevreul's book went into German and English translations and was kept in print for several decades. He became one of the leading Frenchmen of his day. His government struck a bronze medal in his honor, printed a beautiful centennial edition of his masterwork, and erected a full-length statue of him in a Paris garden park. He lived to be 103 years of age (see Illustration 8 and further notes on Chevreul in the next chapter).

When the Franco-Prussian war broke out in 1870, Impressionism had made a fairly substantial beginning. Monet, at age 30, and Pissarro, at age 40, went to London and stood before the luminous paintings of Turner. It is unfortunate that Monet in particular never acknowledged his debt to the Englishman. Monet, though a genius as a painter, was not very articulate in other respects. (Pissarro showed more kindness.) He looked upon Turner's composition as "exuberant romanticism" and was mostly silent thereafter.

But graphic facts tell a different story. Monet made three or four trips to England. He painted perhaps three dozen English landscapes, including several views of Green Park, Hyde Park, and the Thames. These latter canvases bear a remarkable similarity in color treatment to those of Turner (see Illustration 3). There is no doubt that Turner was an influence on the work of Monet, the most typical of the Impressionists. The Neo-Impressionist Paul Signac, who knew his French confrères, wrote: "In 1871, in the course of a long stay in London, Claude Monet and Camille Pissarro discovered Turner. They marveled at the wizardry of his colors; they studied his works, analyzed his technique." Who could not possibly see in Turner one of the true masters of color!

The world of color remembers Monet as a well-disciplined artist. He was a profound analyst of nature. He was especially intrigued by the fleeting qualities of light and illumination. His several compositions on the same subject—haystacks, poplar trees, Rouen Cathedral, water lilies—are in themselves remarkable technical examples of scientific as well as aesthetic inquiry into natural phenomena and human perception.

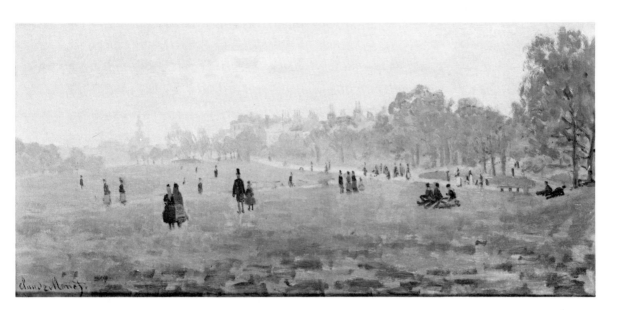

3. Claude Monet, *Green Park*, *London*. (Philadelphia Museum of Art, Wilstach Collection.)

When the Museum of Modern Art in New York ran a Turner exhibit in 1966, the current Director of Exhibitions, Monroe Wheeler, wrote in a catalog, "The French Impressionists and their analysts and critics have, almost to a man, denied Turner's influence, and yet relationship of some sort is strikingly apparent." Wheeler further stated, "Presumably none of the present-day abstract painters whose principal means of expression is light and color had Turner and his lifework in mind, but looking back on their revolution, more than a hundred years later than his, we see a kinship."

After Impressionism came Neo-Impressionism and artists like Georges Seurat (1859-1891) and Paul Signac (1863-1935). This unique school of color devoted itself seriously and quite completely to science. (Illustration 4 shows a typical painting by Seurat. Note the dots and daubs of color.)

For one of the few times in art history, artists' studios were opened to scientists. Attention and respect were paid to English scientists such as Thomas Young and James Clerk Maxwell, to German authorities such as Hermann von Helmholtz—and to America's leading expert on physiological optics, Ogden N. Rood.

Chevreul had written on optical mixtures of color in 1839, as had other writers. Now a new generation devoted itself to visual light phenomena, additive color, afterimages, and the spinning of disks. Ogden N. Rood in his great book, *Modern Chromatics* (1879), had written, "We refer to the custom of placing a quantity of small dots of two colors very near each other, and allowing them to be blended by the eye placed at the proper distance." Neo-Impressionism held a scientific attitude about color, the conviction being that the art of painting could suddenly create luminous effects the likes of which the world had never seen before.

Rood's book was carried around by the Neo-Impressionists as if it were a New Testament of color. It went into French and German editions, and in English it had at least 10 printings over a period of 37 years. This is quite a record. (There were other influences in Neo-Impressionism, particularly the pseudoscientific writings of Charles Blanc, David Sutter, and Charles Henry.)

The Impressionist Camille Pissarro knew the work of Rood well, met Signac, and became an early convert to the divisionist technique of Neo-Impressionism. Other practitioners (but temporarily only) were van Gogh, Gauguin, Toulouse-Lautrec, Emil Bernard, and Henri Matisse.

Unfortunately, the theories of Neo-Impressionism were technically invalid. The visual mixtures of tiny dots of color did not *add* up to lustrous beauty: in reality they went dull and drab. Turner had done a lot better some 40 years before! (Visual mixtures of color strike averages—they do not add up. Red and green, for example, exhibit a strong visual contrast over large areas, but when they blend together in vision, the result is a dull brown, not a yellow or any other vivid color.)

Pissarro gave up Neo-Impressionism with no regret, and so did other friends and associates of his. The theories of the movement weren't correct and didn't work.

Fauvism was the first color and art movement of the twentieth century, and one of its leaders was Henri Matisse (1869-1954). He had studied Neo-Impressionism and wrote, objecting to "The splitting up of form and contour. The result: a jerky surface." Matisse became one of the foremost painters of his day and a great influence on his French contemporaries. He created various styles. In Fauvism he worked with bold colors in broad, flat areas (see Illustration 5). The Fauvists ("wild beasts") slashed their canvases with brilliant hues. Others of this bent were André Derain and Maurice de Vlaminck, who confessed that "We were intoxicated with color."

Fauvism didn't last long. What it contributed to the story of color in modern art was a free and uninhibited use of color—paintings executed as if with "sticks of dynamite."

Concurrently in other European countries a more durable movement was taking place, which also favored candent hues that "blaze in acid stringency." This movement, called Expressionism, is a separate story in itself.

Next came Orphism, which was distinguished chiefly by the art of Robert Delaunay (1885-1941). Delaunay studied Chevreul 70 years after the masterwork on contrast was published. Spectral hues were used in abstract and semiabstract compositions, but they were hardly original or daring after Fauvism.

Among American artists were the Synchromists, Morgan Russell (1886-1953) and Stanton Macdonald-Wright (1890-1972). Working with abstract forms, they understood the difference between additive and subtractive colors and with youthful fervor (c.1911) issued public manifestos of aesthetic revolt. Macdonald-Wright wrote an excellent *Treatise on Color.*

Wassily Kandinsky (1886-1944) dedicated much of his life to color. Although he wrote lyrically about color, his views were quite personal. His

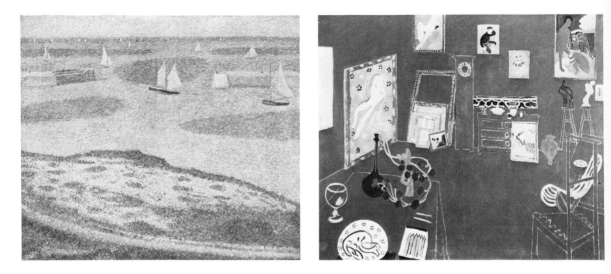

4. Georges Seurat, *Entrance to the Harbor*, *Port-en-Bessin.* Note the divisionist technique. (The Museum of Modern Art, Lillie P. Bliss Collection.)

5. Henri Matisse, *The Red Studio.* A great champion of color and a founder of the school of Fauvism. (The Museum of Modern Art, Mrs. Simon Guggenheim Fund.)

abstract art itself, *in terms of color expression*, revealed little that was new, except esoteric references, "spiritual qualities," and "vibrations of the spirit." His close friend, Paul Klee (1879–1940), showed more ingenuity and was a master at creating delightful moods with color.

No doubt I have omitted other artists and movements which deserve praise. However, space is limited in this little book, and the reader is invited to consult my larger and heavier (5 pounds) volume, *History of Color in Painting.*

Notes on Op Art and other more or less current interests will follow in chapters to come. Today, findings in the realm of human perception are providing new wellsprings and sources for color expression—as this book

hopes to reveal. Perhaps as a holdover from the recent past (action painting), there is a tendency today in abstract forms of color for artists to take short-cuts, to try to be witty and clever, to rely on ideas rather than on a diligent search for knowledge and enlightenment. Compositions must be completed in a relatively short period of time, and public acclaim is lamely won for impulse rather than for concentration and craftsmanship.

One exception is Victor Vasarely, Hungarian-born but a resident of France for over 40 years. Originally trained as a graphic designer, he turned exclusively to fine arts (and architecture) at the age of 36. He is today highly regarded, a popular and successful artist who works in the abstract tradition but with a remarkable and imaginative sense of geometric form and precise color organization. His engaging compositions, often three-dimensional in effect, are outstanding examples of Op Art in its best possible interpretation. Well-disciplined, he is a technician of top rank (see Illustration 6).

To end this chapter, Eugène Delacroix concludes: "The elements of color theory have been neither analyzed nor taught in our schools of art, because in France it is considered superfluous to study the laws of color, according to the saying, 'Draftsmen may be made, but colorists are born.' Secrets of color theory? Why call those principles secrets which all artists must know and all should have been taught?"

And Vincent van Gogh: "It is not only by yielding to one's impulses that one achieves greatness, but also by patiently filing away the steel wall that separates what one feels from what one is capable of doing."

THE DAY OF OP ART
It was bright but it didn't last very long

Just as Neo-Impressionism drew from the sciences of physics and physiological optics, Op Art has drawn largely from the field of psychology. It has concentrated more or less on visual phenomena. Many of its precepts and principles have been lifted bodily from textbooks on psychology. Such phenomena as afterimages, brightness contrast, color contrast, irradiation, Benham's disk, the inability of the eye to focus red and green or red and blue at the same time, the dazzling effects of moiré patterns, and thin black-and-white lines that stimulate color responses have been part of educational inquiries, schoolroom observations, and discussions which many artists have appropriated.

What has been encouraging and foretells progress in the art of color has been a return to knowledge and understanding—after an indifferent period of abandonment to mere impulse in Abstract Expressionism.

Except in the case of artists who have explored meticulous gradations of color and precise geometric patterns (Vasarely), Op Art has exhibited serious limitations. For example, the fact that red and green seen in juxtaposition will dazzle the eye has become an accepted phenomenon, variations of which concern changes in *design* alone. This is because red and blue are at opposite ends of the spectrum and cannot be clearly focused at the same

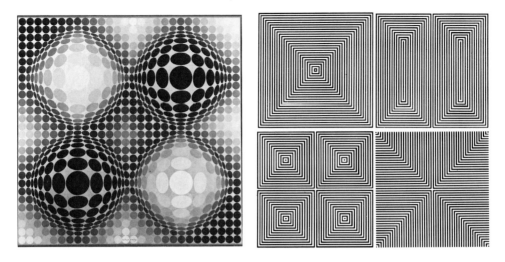

6. Victor Vasarely, *Vega X4.* A masterful control of color and composition. (Collection of Burton Hoffman, Connecticut, photo, Sidney Janis Gallery, New York.)

7. René Parola, *Consecutive progressions and symmetrical compositions.* (From *Optical Art* by René Parola, Van Nostrand Reinhold Company.)

time; the conflict leads to extreme visual excitation. Other complements like yellow and violet do not dazzle, as will be seen. Moiré lines confused in vision tend to vibrate and excite visions of pastels. This is another fact which can be exploited only in design. When you have seen one such demonstration, you have seen them all (see Illustration 7).

Op Art often exhibits bands or lines of color and simple metric forms or areas, some involving simultaneous contrast and others not, and the effects are primarily optical, simplistic, easily recalled to memory, and quite lacking in imagination. All too frequently verbal or literary explanations are required because of a low or limited emotional impact. This is particularly true of what have been called "color field" paintings, many of which display simple colors in large areas and are childishly naive in color choice.

Many artists object to the classification of Op Art and become irate if they are tied to it. But Op Art as here discussed refers to art in which color is

carefully and deliberately controlled (not merely flung about), in which mysteries and phenomena of human vision are studied, and in which there is some pride of craftsmanship. Op Art is automatically (to my view at least) associated with some measure of diligence and discipline.

Much of Op Art has been based on the phenomena of simultaneous and alternate contrast. Reactions here are "optical" in nature and can be clearly described. There are two classical references. One is the recent *Interaction of Color* by Josef Albers and the other is the famous *The Principles of Harmony and Contrast of Colors* by M. E. Chevreul (see bibliography).

To discuss Albers first, his major tome, first issued at Yale in 1963, was beautifully illustrated in silk screen, measured 13 X 20 inches when open, weighed 22 pounds, and cost $200. A smaller paperback edition (6 X 8 inches) was published in 1971, but with only a few of the color plates.

Albers dealt with phenomena such as simultaneous and alternate contrast, afterimages, effects of transparency, additive and subtractive color mixtures, optical mixtures of color, and "Doric columns"—fluting effects—better known as Mach bands. Emphasis was placed on what adjacent areas of color did to each other, how to make one color look like two or two different colors look alike, and "middle mixtures." Albers wrote, "In order to use color effectively it is necessary to recognize that color deceives continually." Agreeing with others, he noted, "Experience teaches that in visual perception there is a discrepancy between physical fact and psychic effect." He mentioned the psychologist's description of surface colors, film colors, and volume colors and expressed his admiration for the work of Goethe.

Much of what Albers discussed, particularly with reference to simultaneous contrast, had been featured in the work of the great Frenchman over a hundred years before. From the standpoint of contrast in Op Art, the leading patriarch was M. E. Chevreul. His book, one of the greatest of all time in the literature of color, was first published in France in 1839, went into the German language in 1840, and into English in 1854 (see Illustration 8). Chevreul's influence has already been mentioned. I shall now describe some

of his discoveries, which were quite sensational at the time and still deserve praise.

Chevreul: "If we look simultaneously upon two stripes of different tones of the same color, or upon two stripes of the same tone of different colors placed side by side, if the stripes are not too wide, the eye perceives certain modifications which in the first place influence the intensity of color, and in the second, the optical composition of the two juxtaposed colors respectively.

"Now as these modifications make the stripes appear different from what they really are, I give to them the name of *simultaneous contrast of colors:* and I call *contrast of tone* the modification in intensity of color, and *contrast of color* that which affects the optical composition of each juxtaposed color."

Here are a few explanations. If a color of light value (brightness), neutral or otherwise, is placed next to a color of dark value, the light value will appear lighter, and the dark value darker (see Illustration 9).

If a chromatic color is placed adjacent to or around a neutral gray, the gray will appear tinged with the hue of its opposite—due directly to the influence of the afterimage. Red will cause gray to appear tinted green; green will cause gray to appear tinted red; yellow will cause gray to appear tinted violet; violet will cause gray to appear tinted yellow; and so on.

Where two *different hues* are placed in juxtaposition (or one within the area of another), the effects are somewhat more complex. With red and yellow, for example, the afterimage of red (which is green) will make the yellow appear greenish; the afterimage of yellow (which is violet) will make the red appear purplish; and so on.

With direct complements, however, there is no hue shift: the afterimage contrasts will heighten the intensity of the hues involved. The afterimage of red (which is green) will naturally make green appear more saturated, while the afterimage of green (which is red) will enhance the brilliance of red, and so on for other direct complements.

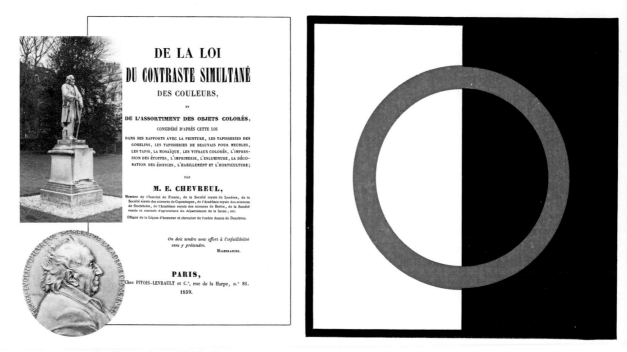

8. The eminent M. E. Chevreul, his book, his monument, and his medal.

9. Brightness contrast. Hold a pencil between the black and white areas and note changes in *brightness* of the gray circle. (Try it with red and green replacing black and white to observe changes in *hue* of the gray circle.) After Kurt Koffka.

Chevreul made an observation which Albers and others have found to be quite true. *Simultaneous contrasts are at a maximum and most noticeable where the two colors are similar in value (lightness or darkness).* Red on green, orange on green, blue on violet—colors which are fairly close in brightness—will quite dramatically influence each other, whereas with colors of different value, such as yellow, which is light, and violet, which is dark, afterimage influences will be less. In these latter instances, brightness contrast seems to inhibit hue contrast. Where grays are concerned (placed next to hues), values *must be close* or the afterimage influences may be negligible.

Chevreul in his day was in charge of dyestuffs and coloring at the world-famous Gobelins tapestry works in France. An early interest in optical color phenomena was stimulated when complaints were made that certain blacks in tapestries lacked depth. As his son wrote, "It was then M. Chevreul found that the purported lack of strength in the blacks had to do with the phenomenon of color contrast and depended on the color with which it was juxtaposed." So the father, noting such curiosities, gave his all to color phenomena and created his masterwork.

What Chevreul further discovered—which surely must have startled the Impressionists and Neo-Impressionists—was that optical mixtures of color did not correspond with pigment or dye mixtures. If red and green, for example, enhanced each other *in juxtaposition*, when they were confused in vision (i.e., combined in threads or, by analogy, in small dots), the same two complementary hues cancelled each other out and formed a muddy brown.

This is perhaps a good place to correct an old and mistaken assumption (and end this chapter), that process printing in which small dots are used involves additive or even visual mixtures of color. The process is essentially subtractive, for the simple reason that *transparent* inks must be employed. Where red dots overlap yellow dots, orange results. Where yellow dots overlap blue (cyan) dots, green results. It is as if the engraver and printer were mixing transparent inks in tiny combinations (components are often invisible). The eye is seeing the results of those mixtures. *If the process inks (magenta, yellow, cyan) were opaque and therefore not subtractive in combination, the graphic result in optical mixtures would be dull and drab in the extreme.*

VISUAL PHENOMENA AND ILLUSIONS
Some of this may be familiar to you; some may be new

In recent years the study of color, particularly as it relates to art, has moved from the laboratory of physics to that of neural (mental) psychology. To say that all color exists in white light is specious: colors can be induced internally by pressure on the eyeball, by hallucinogenic drugs, and by other devices in which the experience of color comes from the inside out rather than from the outside in. Afterimages are one kind of induced colors.

The great Scotch physicist, James Clerk Maxwell, wrote, "The science of color must . . . be regarded as essentially a mental science." In effect, light energy and color may be *out there*, but once light crosses the threshold of the eye, the brain takes over and does astonishing things with it. And at times, as in dreams, the brain may create "pictures" of its own without *outside* stimulation.

To start with the eye, it does operate somewhat like a camera, but the comparison has very narrow limits. A pupil opens and closes to regulate the amount of light that strikes the retina. In a camera the film can be underexposed or overexposed, yet in human vision adjustment to light is constant and automatic: there is no such thing as underexposure or overexposure.

To photograph a white barn on a sunny day and on a cloudy day, one should use a light meter and adjust the camera accordingly. The white barn would be recorded as gray if too little light reached the film. To the human eye, however, the world persists in looking normal—in sunlight or cloudy weather, during morning, noon, or twilight. This phenomenon of color constancy will be discussed in more detail in succeeding chapters.

Vision under bright and dark conditions holds a number of unique features. To begin with, the reaction of the eye to illumination operates not like a light meter—that is, from 0 to 100 and up—but like a thermometer. *Cone* nerve endings in the eye increase in sensitivity as illumination increases: a person sees well under good light. Conversely, *rod* nerve endings in the eye increase in sensitivity as illumination grows dim. When you first walk into a dark room, vision may be poor, for the cone nerves will be blinded. But as the cone responses decline and the rods take over, vision will become fairly clear. The process may take from 15 to 30 minutes. Incidentally, the rods of the retina are more or less insensitive to red. Adaptation to darkness can be developed or maintained under red light or with red goggles. This phenomenon is well known to aviators and to sailors in the conning tower of a submarine.

Interesting things happen to neutral values (white, gray, black) as illumination goes from high to average to low. Under normal light with the cones active, a gray scale will be seen in all its gradations (see Illustration 10). However, as illumination grows dim, white will be perceived, but middle and deep values will tend to blend together. David Katz found that "This darkening tendency appears most strongly in the middle gray steps." In dim light the gray scale tends to shorten from the bottom up (Illustration 10), and the number of distinguishable values seems to be limited to white and deep gray, with maybe an indistinct step between the two.

Illumination creates and destroys space. In terms of human experience, the world expands under bright light and crowds in under dim light. In dim light details are lost. Plastic forms tend to flatten out. Mountains look like flat stage scenery. While yellow and yellow-green are brightest in strong light, green and blue-green appear brightest when the eye is adapted to dim light. In dim light red looks black and all colors tend to be achromatic. (Keep a color circle at your bedside and take a look at it some wakeful night when illumination is feeble.)

Brightness and darkness are associated with light and illumination. Whiteness and blackness are associated with surfaces. Total darkness does not look black but a deep and pitlike gray. A black area will look blacker under greater illumination (even though in fact it may reflect more light).

Blackness is positive as a sensation, not negative. Night descends, night falls, night enters—while daylight retreats. The sensation of black is by no means the absence of all sensation. Full daylight is distinguished by sharp contrasts in lightness and darkness, brilliant highlights and intensely deep shadows at the same time.

Aerial perspective is a phenomenon that has been known to artists since the time of Leonardo da Vinci and before (see Illustration 11). Daylight is bright, night is dark, but great distance is gray.

Intense white and intense black can be seen clearly as such only up close and in bright illumination. (The same is true of intense hue.) As values (and colors) fade into distance, they blend and melt into a medium light gray. Forms also tend to flatten out, and details and textures will be more or less lost.

The large world of color is by no means limited to the pure hues of the spectrum or rainbow. Colored *light*, as distinct from *material* colors (pigments), is ever pure and celestial. The spectrum of the rainbow, which ranges from red, to orange, yellow, green, blue, and violet, contains no black or colors containing black (e.g. brown or olive). In fact, not more than 180

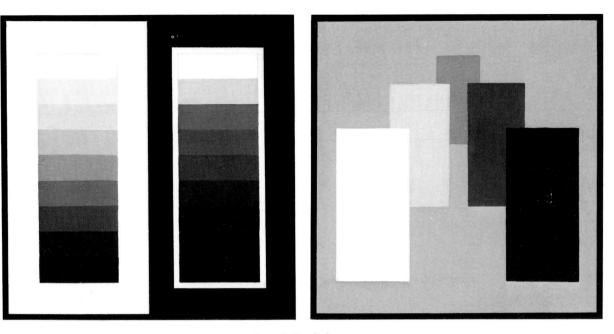

10. The gray scale as seen under bright and dim light.

11. Aerial perspective. All color values blend into a medium light gray as they retreat into the distance.

different hues can be distinguished in pure spectral light, whereas out in the world thousands of color variations are readily perceived. (Authority for the 180 spectral hues comes from Selig Hecht, a scientist at Columbia University, who wrote in 1931, "The normal eye can separate the visible spectrum with complete certainty into about 180 patches of hues which cannot be made to look like one another by varying their intensities.") This means that while innumerable different *wavelengths* may exist in the spectrum, the eye struggles to simplify what it sees and to bunch wavelengths together into neat bundles of red, orange, yellow, green, blue, and violet.

When black and gray are introduced in object and surface colors, distinguishable color variations increase into the hundreds and even thousands. Yet simplification exists here too. Illustration 12 shows the Color Triangle, which has been included in most of my books since 1937. Colors seen in light are usually "unrelated," while colors seen in paints, dyes, or other materials are "related" to the environment in which they appear. In perception the visual process (particularly the brain) tends to classify the world of related colors into seven forms. As the Color Triangle indicates, white, black, and pure color are primary sensations. In secondary forms white and pure color produce tints; black and pure color produce shades; black and white produce gray; and black, white, and color together produce tone. (See my *Creative Color* or *Principles of Color* for further expansion.)

Color vision remains a mystery to science; it can be explained only in theoretical terms. Thick books have been written, as well as numerous articles in technical journals. With color expression in view, I will offer some of my own observations.

Color mixtures with light are *additive.* Primaries are red, green, and blue-violet, and when all three are combined, white is produced. Additive colors are used in color television. Red and green combined in light produce yellow; red and blue-violet produce magenta-red; green and blue-violet produce turquoise or cyan blue.

The secondary hues produced by the additive primaries become the *subtractive* primaries. In process printing, for example, the key inks are magenta red, yellow, and cyan blue (and black). If all three overlap, a deep black is produced.

There is a third set of *psychological* primaries, red, yellow, green, and blue, each of which is a distinct visual sensation. If all four psychological primaries are combined in vision—spun on a wheel, for example—the result is gray. (See Illustration 13 for a graphic portrayal of the three sets of primaries.)

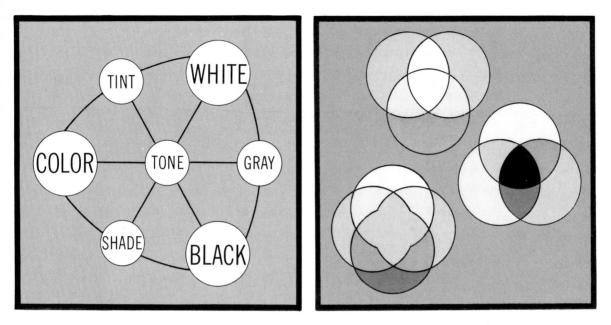

12. Color Triangle. Colors and color variations are grouped into these seven classifications by perception.

13. Light primaries are additive when intermixed; pigment primaries are subtractive; visual primaries are medial.

In the Color Study on the cover of this book, pigments (gouache in the original drawing and printing inks in the reproduction) have been utilized quite successfully to give the impression of light—red light from one side and blue light from the other. Perception, of course, is involved, for what the eye sees is interpreted by the brain in an unusual way. A number of factors contribute to the result. To simulate light, both the red and the blue have been applied with soft transitions toward the center of each square. Light naturally has this effect.

Colored lights, when mixed together, are additive and produce a bright overlap. Pigments, on the contrary, are subtractive when mixed together, and the overlap becomes dark. *The pale grayish transition between the red and the blue on the cover was specially mixed in opaque pigments and has a lighter value than either the red or the blue.* In effect, the pigments were handled as if they were lights, and perception quite willingly goes along with the illusion. The facts of the Color Study on the cover are one thing (pigments), but the interpretation is another (lights)!

The illuminated squares are immediately surrounded by a soft, grayish blue. This sets up a Field Size (see page 51) that is suppressed in tone and, by comparison, adds luminosity to the red and the light blue. A further deep, grayish blue contributes still more contrast between grayness and color purity.

Only five colors were mixed for the Color Study on the cover, but great patience, understanding, and strategy went into them. Two realms of color, surface and film, were brought together to enable the medium (paint) of the artist to be transcended, to explore a unique world of color that lies conveniently within the human psyche—and to enable the artist to treat the viewer to strange sights that require an active role from perception.

By way of side comment, there is a difference between colored light and colored pigment. Pink light on white snow would not look the same as pink snow with white light shining on it. The Color Study on the cover is remarkable because both the pink and the blue pigments have the aspect of light. Human perception is responsible for this interpretation.

There are *warm* colors, such as red and orange, and *cool* colors, such as green and blue. The psychologist calls the warm colors *hard*, and the cool colors *soft*. The warm colors tend to dominate the cool colors. If a red card is exposed to one eye and a blue card to the other, the brain will insist upon seeing the red longer and more often than the blue.

Warm, hard colors "segregate" better than cool, soft colors. A red symbol or letter on a blue background will segregate better than a blue symbol on red. Red will be far more conspicuous than blue on a gray background. Op Art has graphically expressed this fact. Involved with hardness and softness of color, with warmth and coolness, is the matter of optical perspective. Red normally focuses at a point behind the retina, causing the lens of the eye to become convex and to pull the red forward, making it appear both nearer and larger. Blue normally focuses at a point in front of the retina, causing the lens of the eye to flatten and to push the blue back, making it appear farther away and smaller. Op Art has also featured this phenomenon.

Under bright light and in highlights, colors tend to shift upward toward yellow in hue, red becoming more orange, blue becoming greener. Under dim light and in shadows, colors tend to shift toward violet, red becoming more purple, blue becoming more violet. True highlights, unless they are specular reflections, are never tints of the base color, but literally appear to have increased saturation. Much of Rembrandt's luminosity with color paid respect to this: his golden flesh tones, for example, were purer and more brilliant than other areas on the canvas.

As an encouragement to abstract art, it should be understood that color takes precedent over form, pattern, and design. David Katz wrote, "Color, rather than shape, is more closely related to emotion." How is this demonstrated? When Katz presented small children with an assortment of different shapes (squares, triangles, and circles) in different colors (red, yellow, and blue) and asked them to group like objects together, the children saw "likeness" in terms of color rather than form. The ambiguity of the experiment—color versus shape—is not questioned at a young age but requires some maturity and worldly experience. Wrote Katz, "This finding confirms the primacy of color in creating form."

Color Studies I and II exploit color in a *visual* (rather than *perceptual*) manner.

Color Study I is a tribute to Georges Seurat and the school of Neo-Impressionism. The vibrant effect here is what Seurat tried to accomplish but without success. Involved in this demonstration are the following principles.

First, nine saturated colors are placed in analogous order: purple, red, orange, yellow-orange, yellow, yellow-green, green, turquoise, and blue. Careful attention was paid to relationships and discernible differences: fewer or more colors might not produce the effect. (Many arrangements were originally tried.)

Second, note the wavy stripes. If colors are confused through head movements and the stripes are too close together to be seen separately, any optical mixture or overlapping tends to heighten saturation and create a vibrant shimmer. Brilliance is maintained because the colors are related to their neighbors. Seurat and his contemporaries made the mistake of mixing opposite rather than analogous hues in their divisionist technique, thus putting colors into collision and dulling their results.

Third, the clusters of stripes vary in width from the center outward. There is vibrancy in any cluster, whether the study is seen from nearby or from a distance. Up close the narrower clusters of stripes vibrate, and the stripes of the wider clusters are distinctly separate. As the viewer moves farther away, the wider clusters also begin to vibrate. (While these effects are none too dramatic in the small color plates in this book, if the studies are increased in size, using the same hues, vibrant effects will be evident from greater distances.)

Because Neo-Impressionism used dots and dabs of equal size, precise distances for viewing were demanded. Even then optical mixtures went flat. In Color Study I, the clusters of stripes in different widths make it possible to retain the vibrancy at *different* distances.

The organization of Color Study II repeats that of Color Study I but with softer hues. This I would like to offer in tribute to Joseph Mallory Turner. The general effect of Color Study II is less lustrous than Color Study I but at the same time luminous and iridescent.

The principles given above apply also to Color Study II: hues are analogous; the widths and waves of the stripes force optical mixtures; because the clusters of stripes vary in width from the center of the composition outward, vibrancy is seen at any distance (particularly if the study is enlarged).

In his day Turner made the remarkable discovery that if pure hues or rich pastels were shaded toward slightly deeper grays or neutrals, strikingly luminous effects followed. Sunsets lit up as if by magic. Although painters of his generation were supposed to glorify nature, Turner became so engrossed with color as color that he often abandoned himself to his oils and watercolors and, as if guilty of some offense, added a touch of vague realism that was hardly noticeable unless the viewer looked for it. Unconsciously, perhaps, Turner became one of the first abstract glorifiers of color.

So much for the eye and for optics. The story will now proceed beyond the retina and up the optic nerve into the human brain where perception sits enthroned.

THE MYSTERIES OF PERCEPTION
How the brain is put to creative effort

A good way to enter the domain of visual perception is to begin with a discussion of what the psychologist calls *modes of appearance* for color. The science of physics becomes largely irrelevant here; color becomes a personal study, and the research laboratory is a person's own consciousness. The reader must turn away from the outer world of academic references to color to the world within (perception).

Say you have a piece of red glass, a sheet of red paper and a white light bulb, and a sheet of white paper and a red light bulb. It is entirely conceivable that by holding the red glass to a window, illuminating the red paper with the white light bulb, and illuminating the white paper with the red light bulb, three *identical* reds could be created. To a physicist and perhaps to a spectrometer's measurement, three matching reds would be registered.

Yet the three reds would be quite different psychologically to perception. One would look transparent; another, like an opaque surface; and the third, like a red-illuminated surface. There would be three different modes of appearance for the same color.

The experiment could go further (see Illustration 14). One could add to the collection swatches of red silk and wool, a red Christmas tree ornament, a red lamp, a glass of red liquid, etc. All the reds might be the same *physically* but quite unlike *psychologically*.

There are two remarkable phenomena in the process of seeing with eye and brain: color constancy and a human sense of illumination. The next two chapters will be devoted to them. In this chapter I will make some introductory observations, which, for the most part, are fairly new to the literature and art of color.

The psychologist speaks of surface colors, film colors, and volume colors. *Surface colors* are those seen in the world, the colors of substantial things and objects. Some may have different modes of appearance, but they are tangible and touchable. *Film colors* are seen in the sky. They are atmospheric and they tend to fill space. They have no substance. *Volume colors* are those that have three-dimensional boundaries. A jar of colored liquid would have a volume color. Fog might be a film color if it extended into empty space. If something were seen through the fog, the fog might seem to occupy the space between the eye and the object seen through it, thus becoming a volume color.

Are these distinctions valuable to the artist? If the wonders of perception are to be exploited for new modes of color expression, new mental attitudes should be encouraged. If film colors have no texture, a painter would do well not to let texture contradict what he is trying to portray—a sky, for example. If the viewer of a composition saw the texture and weave of the canvas showing through a pale blue paint, the sky would seem near, not far (see Illustration 15). Painters such as Whistler were able to convey a vivid impression of atmosphere, space, and volume colors by placing a few bright and luminous spots of color within a soft and suppressed field. These luminous spots indeed looked far away. The Japanese also were masters at letting mere paper or thin washes of color imply great distances—film color, volume color—and the viewer's perception was called upon to participate in the effect.

Incidentally, surface colors can be made to look like film colors by viewing them through an aperture screen (a card with a hole in it). If the texture is not too pronounced, a color that looks flat and two-dimensional

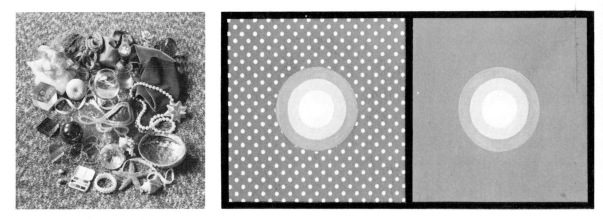

14. Colors can have widely different modes of appearance.

15. Texture appears near, as at left. Space and distance are filmy.

will, on looking at it through the hole in the card, appear filmy and as if it were filling space beyond the card.

The mind is ever active in perception. In the phenomena of simultaneous and alternate contrast, discussed under Op Art, color appearances were found to change and shift through the influence of afterimages. Another strange happening was revealed by the German psychologist Ewald Hering (see Illustration 16).

A white card is placed on a windowsill, with an observer standing in front of both. In the hand of the observer is a second white card with a square or round hole cut in the center. With the top card held parallel to the card on the windowsill, both whites will match in brightness. However, if the top card is tilted toward light coming through the window, it will naturally become brighter, and the card seen through the aperture will look gray. If the top card is tilted away from the light and thus made to reflect less light, the underneath card will become brighter.

What is remarkable here is that the card on the windowsill, *which hasn't changed at all in brightness*, is the one that looks dark at one time and light

at another. The eye and brain have adapted to the top card, thus ignoring the *facts* about the bottom card. Control of adaptation, to be discussed later, offers the artist new approaches. It is important to *think* and not merely to *look*.

Perception tends to dissociate itself from actual physical facts. In color constancy a black area under brilliant illumination may reflect more light than a white card under dim light, but the visual (perceptional) impression will be of black and white nevertheless.

David Katz wrote, "All visual percepts are influenced by knowledge that comes from experience." Let me see if I can make this clear. For too many years the art of color has looked outward for its principles—to arbitrary notions of harmony, to phenomena in nature, to physical facts of color (the eye as a mere receptor), to visual facts (i.e., contrast effects, optical color mixtures). All the while there was another world to enter—human consciousness and human perception. In my *History of Color in Painting:* "Beauty (or ugliness) is not out *there* in man's environment, but *here* within man's brain. Where formerly some artists strove to find laws in nature, now one may be sure that such laws, if they exist at all, lie within the psyche of man. The perception of color—involving feeling and emotion—is the property of human consciousness. If man is awed by what he sees in his surroundings, he should be far more impressed by what lies within the sanctuary of his own being. This is where to look, not in ignorance but in sensitive understanding."

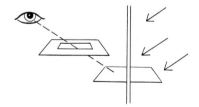

16. The illusion of Ewald Hering.

A SENSE OF ILLUMINATION
Though it constantly operates, it is seldom noticed

The Neo-Impressionists studied physics and additive mixtures of color. The Op Artists delved into psychological aspects, visual illusions, optics. This chapter moves in still another direction—perception and neural responses to color.

Visual perception has become the subject of wide investigation. There are remarkable things to learn about perception, which, while obvious enough when pointed out, have not been noted or comprehended by the majority of artists. One is reminded of the discoveries and observations of Sigmund Freud—the ego and the id, infantile sexuality, the Oedipus complex, free associations, repressions—theories which, though bitterly attacked in the medical field, led to the science of psychoanalysis and greatly influenced the schools of Surrealism and Expressionism in art.

If the substance of this chapter is confusing to the reader, if it is difficult to comprehend in whole or in part, please bear in mind that all points made and all references given may be traced directly to the reader's own consciousness. With words, charts, illustrations, and color plates, an effort will be made to lead the art of color in new directions and to get the reader thinking in different but entirely understandable terms.

To begin with, it is important to realize that the study of color phenomena in the past has been concerned largely with physics, optical factors, and visual receptors. Now the shift is toward neural (mental, brain) events in the process of seeing. Contrast effects, afterimages, colored shadows, and Benham's top are now being analyzed and explained in new ways—past the eye and the optic nerve to the brain.

Try the following experiment. In a dimly illuminated room, look with one eye at a 40- or 60-watt light bulb in order to create a positive afterimage. Then look at a spot on a wall. If you jiggle your eye from the side, the afterimage will *not* jiggle. But if you glance from one point to another, the afterimage *will* move wherever you direct you attention. Where, then, is the image? Within your brain? Not in the eye, obviously.

Concerning illumination, David Katz wrote, "With the same immediacy with which we perceive the colors of objects comes the apprehension of their illumination." A person does not have to look at a light source to know whether an environment is bright or dim: he can tell by the appearance of things within the field of view. Katz further stated, "The way in which we see the color of a surface is in large measure independent of the intensity and wavelength of the light it reflects."

Stated again, this time by the German psychologist Ewald Hering, "Seeing is not a matter of looking at light waves as such, but of looking at external things mediated by these waves; the eye has to instruct us, not about the intensity and quality of the light coming from external objects at any one time, but about these objects themselves."

A sense of illumination seems to be an independent factor in perception. With even a moderate amount of training, the average person can pretty well determine the brightness level (value) of different shades of gray. But who can accurately judge the illumination level of different degrees of light intensity? Ralph Evans, an authority on photography, wrote, "The eye . . . cannot be used as an adequate meter for illumination intensities."

Yet illumination is always sensed—chiefly by looking at the appearance of objects and surfaces in the world and not at light sources.

Changes in pupil size contribute to a sense of illumination, but with reservations. With illumination unchanged, for example, the pupil will constrict if exposed to a broad expanse of white, and expand to a broad expanse of black. In life the eye seems to struggle to achieve an average brightness of surfaces and areas before it. Beyond this, however, if objects and surfaces are very bright, illumination will *seem* bright; if there are darker values in view, illumination will *seem* dim.

Manifestations of this phenomenon can be used to create new color expressions. Under normal illumination and up close, the world of color is seen in all its "genuine" hues and values. In Illustration 17 shades of gray are scaled from a center white band to a black band and placed on a white background; brightness contrasts are maximum. Such scaling of *chromatic* colors, incidentally, will lead to effects of luster, particularly if pure hues are used (see the upper-left areas of Color Study III and Color Study V).

In Illustration 18 dim illumination is graphically portrayed in black and white with a scale of five steps from white to deep gray. The background is dark gray. As already noted in this book and shown in Illustration 10, as illumination grows dim, all deep values tend to blend together. Genuine colors do not appear as such but become blackish and muted—as in the lower-right area of Color Study V.

In Illustration 19 atmospheric mist is simulated with a series of four grays (including white). The background is a light gray. Aerial perspective is involved here. As chromatic colors become more distant, they become grayish in character—as in the upper-right area of Color Study V.

Illustration 20 attempts to achieve the effect of luminosity. Again, a series of four grays is used, as in Illustration 19, *but the background is a medium rather than a light gray.* Luminosity for chromatic colors, following the same principle, is expressed in the lower-left area of Color Study V.

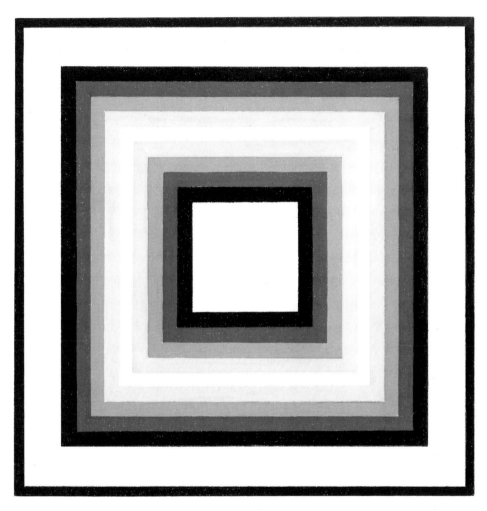

17. An effect of normal illumination.

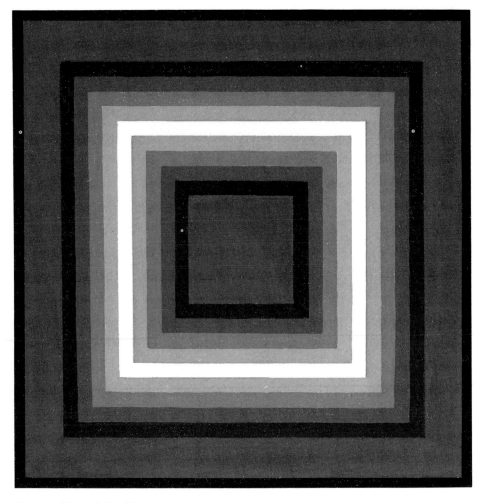

18. An effect of dim illumination.

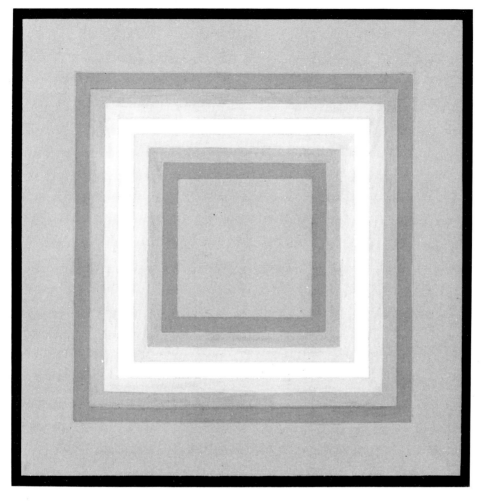

19. An effect of atmospheric mist.

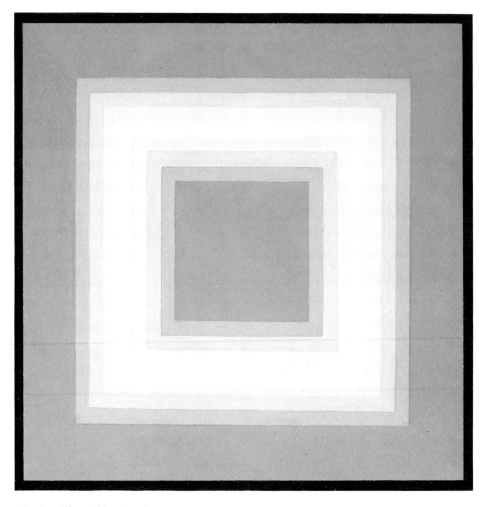

20. An effect of luminosity.

Tricks are being played on your perception if the effects described above are confirmed in your visual experience. In all four black-and-white illustrations the center stripe is the same white. A uniform and identical white also appears near the center of each of the four areas of Color Study V.

As a variation on Illustrations 19 and 20, a light background lends the impression that illumination is coming from *behind* the gray scale, throwing the scale into shadowy silhouette. This is indicated in Illustration 21.

Many artists in the past have understood the illumination effects described above and have featured them in naturalistic and representational paintings. But who in the abstract field has ever seriously studied the perceptual aspects of vision, the human sense of illumination? There is a new world to conquer here.

To refer again to Color Study V, let me repeat that an identical white appears near the center of all four areas. As will be stressed in the next chapter, in the engaging phenomenon of color constancy white always appears white as long as the eye can see it—independently of the amount of illumination it reflects! The white in Color Study V is the common denominator—perceptionally—and is the only identical note in all four areas: all other colors, shades, and tones differ from each other.

It may be noticed that the white in the luminous area of Color Study V, lower left, appears deeper and grayer than the other whites. This deeper appearance is due to a lack of value contrast—this white is exactly the same as the other whites.

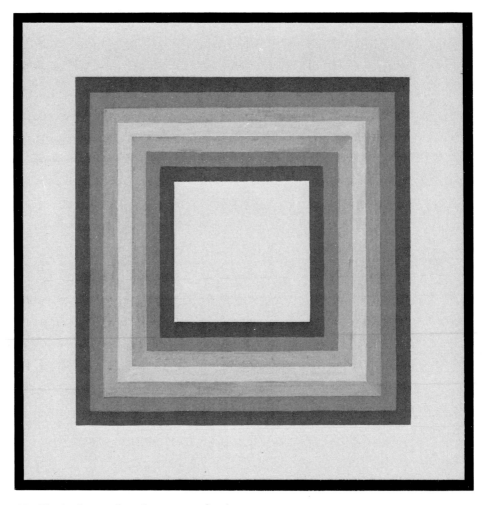

21. The background tends to appear luminous.

The artist may create impressions of illumination in this manner. Katz wrote, "Changes in illumination intensity may easily escape notice, at least more easily than changes in brightness or surface color." Reversing this, different appearances of illumination may be accomplished by controlling and manipulating surface colors. Strong contrast and saturated color imply strong illumination. Large areas of subdued color suggest either dim illumination or atmospheric mist. Katz stated that "The *more* of a picture we perceive, the clearer the impression of the illumination which the artist is representing." Thus a larger canvas has an advantage over a smaller one in creating illusion. "The color of a small area of a picture signifies nothing in itself; it contributes to the illumination-impression only when it is grasped as part of the whole."

I hope that these observations, evident in human experience—yours and mine—will inspire the reader to think of color in fresh ways. There is more to come, however. Beyond the sense of illumination there are such intriguing phenomena as color constancy, visual adaptation, luster, iridescence, luminosity, transparency, colored light—all within human experience and all awaiting development and exploitation in the future.

THE MAGIC OF COLOR CONSTANCY
Including notes on what may be called the Law of Field Size

Chevreul, Helmholtz, Rood, and others had the artists of the late nineteenth and early twentieth centuries thinking about simultaneous contrast, afterimages, additive colors, light primaries, and visual color mixtures. This source material influenced the schools of Impressionism, Neo-Impressionism, and Fauvism. Retrogression followed (in terms of color) in Cubism and later in Abstract Expressionism. Eventually the psychologist replaced the physicist as mentor and influenced the school of Op Art. Today, perception is the big field of inquiry, the new incentive to progress in the art of color—and the chief subject of this book.

The sense of illumination was discussed in the preceding chapter. Now other unique phenomena will be described—color constancy, adaptation, the Law of Field Size—principles with which the artist can transcend his materials and create effects of luminosity, luster, iridescence, transparency, chromatic light—the effects that are seen in the geometric color studies of this book.

David Katz wrote, "There seems to be an independence of the colors of objects from the change of illumination." Consider the following possibility. A gray hen standing in full sunlight in a barnyard and a white hen standing

in the shade of the barn would appear gray and white, respectively, if you witnessed the scene, even though the gray hen reflected more light into your eye than did the white hen. A camera in this instance would be confused: the gray hen might look white on a photographic print, and the white hen might look gray.

Again, say you hold a white handkerchief in your hand in full sunlight. A cloud passes over the sun. You enter a house, go through a room, and down into the basement where illumination is feeble. *The handkerchief still looks white!*

This is *color constancy*. David Katz stated that in bright light white has high "pronouncedness," while in dim light it has low "pronouncedness," but the sensation remains white. Vision struggles to see the world as normal under astonishingly varied conditions of illumination. If a sequence of photographs were to be taken of the white handkerchief above, the photographer would be kept busy adjusting the lens opening and the time exposures of his camera. Even at that, his photographs would never be true pictures of what a person actually saw.

Ralph Evans wrote, "The range of intensities visible to the eye is far in excess of a million to one." In nature brightness differences between the sky and black earth may be on the order of a thousand to one. In a painting, design, or photograph, if an area of white reflects 80 percent, and an area of black 5 percent, the ratio is a mere 16 to 1. (In color television brightness ratios are usually only 6, 7, or 8 to 1.) Yet artists have been able to portray sunlight with remarkable conviction. How?

Even more astonishing is the maintenance of color constancy under chromatic light, a phenomenon that defies physics. From dawn to midday to dusk, natural light may vary in tint from pink to orange, yellow, white, pale blue, and back to pink at dusk. A person may be conscious of this change in illumination, but color constancy will prevail and the colors of the world will tend to appear "genuine."

[handwritten margin note: PERVASIVENESS WHAT I CALL A COLOR'S FLAVOR]

Even under intense chromatic light, color constancy will persist. M. D. Vernon wrote, "Again, a white surface in a red light may up to a point appear less red than a red surface in white illumination, even when the former reflects more red light than the latter." While there is greater constancy over differences in white light, nevertheless, constancy under chromatic light is amazing indeed. (Intelligence plays no role in the phenomenon of color constancy: the same talent has been found to exist in birds and beasts.)

Artists for centuries have been painting the world as they saw it. Without being particularly aware of color constancy, they have paid respect to it. A painter might stand before his easel in a poorly lit studio and yet portray a sunny, outdoor scene. Or in bright light he might portray a candlelight scene. Artists have painted sunsets, moonlight, Indian summer, brilliant deserts, misty mountains. Though the paintings may be seen in a museum or on the walls of a home or gallery and under radically different conditions of interior illumination, color constancy in all cases will come to the rescue and hold the painter's vision intact.

Much of the work of older masters had the appearance of studio painting and probably was undertaken in the studio. The Impressionists were among the first to pack up palettes and canvases and go out of doors where light was clear and strong. And what they painted often retained this natural brilliance indoors.

All through life there is continual adaptation of the visual process to light and illumination, both to degree of intensity and to chromatic tint. Nature has given man an innate sense of normalcy in his perception of the world. He has a built-in light meter that is automatic, plus a built-in set of color filters which keep colors looking "genuine," whether they actually are or not.

In the last chapter, Illustrations 17, 18, 19, 20, and 21 were meant to convey impressions of normal illumination, dim illumination, mist, luminosity of a medium ground, and medium grays on a luminous ground. A

uniform series of grays was used for the illustrations, but the values were arranged in different sequences. Involved here is the Law of Field Size. As seen in the black-and-white illustrations (and as will be described later with reference to chromatic hues), control of brightness can lead to different perceptual impressions.

Bright light is distinguished by a general distribution of high values over a composition, emphasized by extremely deep accents. In nature white and black can be seen clearly only when they are brightly illuminated and up close.

Dim light is distinguished by a general distribution of dark values, but not full black itself. In dim light deep values will tend to blend together. White may still be seen as white, but it will have less "pronouncedness."

In mist conditions, values tend to blend toward a light or medium-light gray. White will also be less "pronounced." If details are shown in lighter values than the ground in a misty composition, luminosity will be implied in the details. If details are shown in slightly deeper values than the ground in a misty composition, a luminous background will be implied.

Although these observations are plausible enough in regard to situations found in nature, *few artists have endeavored to feature them in nonobjective art!*

color theory → VARIABLES
→ CONSTANTS (ANCHOR VARIABLES)
Think of variables in terms of scales and range.

NEW REALMS OF EXPRESSION
Principles, comments, details, and explanations of the Color Studies

Color Studies I and II were described on pages 32 and 33 in the chapter on Visual Phenomena and Illusions. While these studies were designed to illustrate visual and optical color mixtures, they also suggested effects of luster and iridescence. This chapter summarizes the major topics of this book, with references to all 12 Color Studies plus the cover.

The Principle of Luster (Color Study III). To appear lustrous, colors need great purity of hue and strong contrast, preferably against black. Lustrous colors as a rule are more intense than ordinary surface colors. With folded silk, for example, highlights are brilliant, and shadows are extremely deep—a fact well appreciated by the old masters. Incidentally, the true highlight of a vivid color is never a tint of it. Luster is dramatically implied if the feature colors are strong and clean and if gradations and shadows fall suddenly into black—with no grayness anywhere.

The Principle of Iridescence (Color Study IV). Unlike luster, the beauty of iridescence needs gray (not black) contrast. If an iridescent composition is planned, whether realistic or nonrepresentational, the "shimmery" hues should be as pure as possible; rich pastels are recommended rather than full hues. *Most important of all, the gradations must work toward neutral grays of slightly lower value*. With the field size muted and soft in tone, the rich

iridescent touches will, by comparison, shine forth brightly. Bear in mind that in nature iridescence is not due to pigments but to fine screens, lines, or crystals that break up white light into the hues of the rainbow (butterfly wings, opals, oil on water).

Pigments Converted to the Appearance of Lights (Cover Color Study). The effect here has been well described on pages 29 and 30 in the chapter on Visual Phenomena and Illusions. To review, to make pigments resemble lights, the technique of the artist should be soft and filmy. The color or colors meant to look like light must be exceptionally clean in hue. Any blending must also be soft, not harsh. *If simulated lights meet or overlap each other, the intermediate tone must be somewhat neutral and higher in value than the colors that compose it.* Lights are additive, not subtractive, in mixtures. A red pigment overlapping a blue would make a deep violet or purple. In lights the intermix would be a pale lilac—precisely as in the Color Study on the cover.

Illumination Effects (Color Study V). This effect is discussed on pages 40 and 45 in the chapter on A Sense of Illumination. Principles are described as they relate to color phenomena in human perception.

The Principle of Luminosity (Color Studies VI and VII). Much can be said about creating the effect of luminosity with ordinary art materials. If you hold a piece of white paper in your hand and if light shines over your shoulder, the paper will appear *illuminated*. If you turn around and hold the paper so that the light shines through it, the paper will appear *luminous*. David Katz wrote, "A color must be brighter than a white surface under the same conditions if it is to be characterized as luminous." And again, "Colors which appear filmy or voluminous must exceed their surroundings in brightness if they are to produce the impression of luminous color."

Katz's remarks have been well applied to Color Studies VI and VII, the first in a blue environment and the second in a violet one. *The central squares in yellow, pink, green, and blue are the lightest and purest areas in*

view. As sequences go outward, the colors grow (a) duller and (b) a trifle deeper. This muted Field Size effectively builds up the illusion of luminosity in the central squares. Subtle sequences like this are far removed from the conventional ways in which Op Artists have scaled colors from one hue to another. In Color Studies VI and VII, perception, not mere optics, has been put to work. The central colors are not actually luminous: they only appear so as the human brain looks the composition over and decides that luminosity must exist because all factors involved in the phenomenon have been convincingly presented—and with pigments at that!

Luminosity has other features. If light actually shines into your eyes, a blurring effect results. The luminous color will cast its tint over its surroundings. Say, for example, that a traffic light is to be portrayed with the red lens shining. If the red is surrounded by black or a complementary dark green, the "light will go out." Red and black or red and dark green side by side will imply illumination coming from outside, for if the red really were shining, it would blur and diffuse any adjacent black or dark green. The effect of luminosity demands contrasts of color purity against grayness, somewhat like the principle of iridescence but with the luminous color casting its glow over its surroundings.

In Color Studies VIII and IX, luminous or perhaps iridescent circles are seen as if imposed on a background that in the first case seems pervaded by a blue illumination, and in the second by a yellow-green. (The principles involved in the background effects of Color Studies VIII and IX will be further elaborated on the succeeding pages devoted to a discussion of Chromatic Light and Color Study XII.)

The blue background of Color Study VIII may suggest the appearance of a group of *normal* hues under the influence of soft blue light or blue mist. This in fact is the case. A normal palette made up of white, red, yellow, green, blue, and purple was studied under the influence of a soft blue illumination. *The key colors were then matched in pigment*. Perception, presented with areas of pigments that looked as if they were pervaded by colored

54

illumination, put the brain to work—and the result is as you see it in Color Study VIII for blue (and Color Study IX for yellow-green). The circles, in contrast, appear luminous or iridescent because of (a) higher brightness and (b) cleaner tint.

The Effect of Transparency (Color Studies X and XI). In his *Interaction of Color*, Josef Albers discussed and illustrated effects of transparency using opaque materials. Attention was also given to additive and subtractive color mixtures (see Illustration 22).

Effects of transparency offer great possibilities in nonobjective or abstract art. In perception, for an object to be transparent, something must be seen through it. Simulations of transparency, however, involve problems.

In Color Studies X and XI, the transparent squares, one in red and one in green, were painted in *opaque pigments* to look the part. If squares of transparent red or green plastic had actually been laid over the background geometric pattern, the background colors would have been uniformly dark. (The reader can try this for himself by laying red or green cellophane over the prints.) What was necessary for the effects of Color Studies X and XI was to paint the transparent areas of the squares to match the background colors as they actually appeared when *looking through* red and green film (see Illustration 23 for the general procedure).

Illustration 22 charts the difference between additive, subtractive, and medial color mixtures. Only in the center is transparency well implied. The bottom section, which is comprised of two grays, seems unreal. Such an effect would be possible only if the superimposed area was translucent or "milky," and this is rarely experienced in life. (Many abstract painters have shown medial mixtures, which, for the most part, have lacked conviction.)

The Effect of Chromatic Light (Color Study XII). Chromatic-illumination effects in nature are limited to pink, orange, yellow, white, pale blue—and sometimes eerie grays before a storm. Artists of the past have successfully conveyed these atmospheres, and they properly belong to naturalistic art.

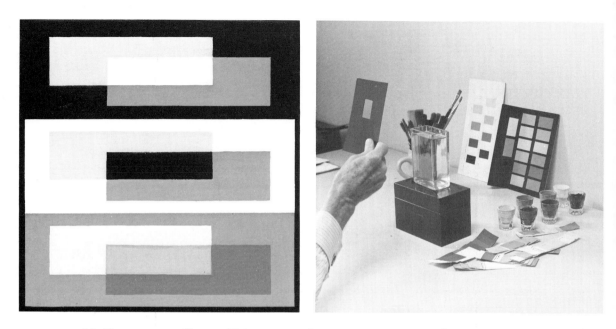

22. Transparency effects: additive at top, subtractive in center, medial at bottom.

23. Arrangements for the study of chromatic light effects.

But the abstract artist may consider—what if nature had also drenched the world with green, turquoise, blue, or violet illumination?

Color Study XII shows four chromatic-illumination effects in red, yellow, green, and blue. In each instance the viewer is fairly well convinced that what he sees might be a group of normal colors enveloped in a hued light. He is not looking at pigments or paint per se, but at colors under tinted illumination.

How were the palettes for Color Study XII developed? Look at Illustration 23. First, a basic chart of normal colors in medium and rich tones of red, orange, yellow, green, blue, and purple was set up (plus white, gray, and black). Pieces of transparent plastic, glass, or theatrical gelatin were placed in

front of the chart. Using a black card with a square hole in it, the artist looked through the transparent color to the basic chart *and matched what was seen*. (Alternatively, one might set up a glass tank as employed in slide projectors, fill it with water, and add clear dyes for any desired hue, following the same procedure as with colored film.)

Then a pigment palette adjusted to the influence of colored light was created. Result? When the artist executed a composition, realistic or abstract, it would be as if he were painting with colored light itself. As in Color Study XII, perception stood at the artist's side and saw, not a mere color *scheme* of various hues, tints, and tones, but a color *effect* dominated by an illusion of chromatic illumination.

A chromatic light, such as red, shining on a complementary pigment, such as green, will result in a very deep neutral resembling black. If a chromatic red light were shone on a red pigment itself, saturation (hue purity) would be exceptionally strong and difficult to match in paints. Pigment colors intermediate to the chromatic light will cause less of a problem. Red chromatic light will turn yellow into orange, blue into violet, etc. Once an artist gains experience in the effects of colored light on colored surfaces, the phenomena involved will be easily understood, and the artist can readily master the results shown in Color Study XII.

A pigment palette can be established, which, in application, becomes a colored-light palette—thanks to the generosity of human perception in admitting this interpretation. The conventional limits of color expression are thus expanded.

Referring back to Illustration 23, it is practical to have a daylight source coming from the left. The chart of normal colors can then be turned on its vertical axis, usually *toward* the light, so that the colors will brighten, be less deep under the influence of the colored film, and therefore easier to match. One suggestion is to look at white on the chart, select a pigment that corresponds more or less to the hue chosen for the colored film (or the tank color), and adjust the chart until a near match is achieved. With the angle

of the chart so fixed, you can try your best to match the other normal colors as you see them through the colored film (or tank).

Once an artist comprehends the effect of colored light on colored pigment he can cast films, tanks, and charts aside and be creative without bothersome encumbrances.

Many years ago Sir Joshua Reynolds wrote, "There is not a man on earth who has the least notion of coloring; we all of us have it equally to seek for and find out, as at present it is totally lost to the art."

I hope that now the art of color is finding its way again.

ANNOTATED BIBLIOGRAPHY

The 35 books listed below have all been consulted to a greater or lesser extent. From the brief annotations the reader may use his judgment in choosing sources for further reference. Some are technical, some general, and some related to art. Note the works on color and perception, one of the most researched subjects of the day.

Josef Albers, *Interaction of Color*, Yale University Press, New Haven, 1971. This is the small edition of Albers' great work. Identical text as the large original, but with fewer illustrations.

Rudolf Arnheim, *Art and Visual Perception*, University of California Press, Berkeley and Los Angeles, 1957. An outstanding study of perception from the aesthetic viewpoint.

Jacob Beck, *Surface Color Perception*, Cornell University Press, Ithaca, N.Y., 1972. A general review of the subject.

Edwin G. Boring, *Sensation and Perception in The History of Experimental Psychology*, Appleton-Century-Crofts, New York, 1942. An excellent general treatise, but only partly concerned with color.

M. E. Chevreul, *The Principles of Harmony and Contrast of Colors*, with introduction and notes by Faber Birren, Van Nostrand Reinhold Co., New York, 1967. One of the greatest books on color ever written (1839) and a vital influence on Impressionism and Neo-Impressionism.

Eugène Delacroix, *The Journal of Eugène Delacroix*, translated from the French by Walter Pach, Covici, Friede, Inc., 1937. A rarity among painters, he wrote eloquently on color phenomena.

Ralph Evans, *An Introduction to Color*, John Wiley & Sons, New York, 1948. This has become a standard work on virtually all aspects of color. Despite the title, the text is rather complex.

Ralph Evans, *The Perception of Color*, John Wiley & Sons, New York, 1974. This authoritative work, published posthumously, introduces new concepts in the mysteries of color perception.

James J. Gibson, *The Perception of the Visual World*, Houghton Mifflin Co., Boston, 1950. A well-written and -illustrated treatise.

Johann Wolfgang von Goethe, *Goethe's Color Theory*, arranged and edited by Rupprecht Matthaei, Van Nostrand Reinhold Co., New York, 1970. A magnificent treatise on Goethe's color theories (1810), which have recently gained wide recognition.

Kurt Goldstein, *The Organism*, American Book Co., New York, 1939. Although somewhat out of date, this book presents intriguing references to the influence of color on human behavior.

Clarence H. Graham, editor, *Vision and Visual Perception*, John Wiley & Sons, New York, 1965. A review of various aspects of the subject.

R. L. Gregory, *Eye and Brain*, McGraw-Hill Book Co., New York, 1966. This book, in paperback, is highly recommended for its clear exposition and striking illustrations of visual illusions.

R. L. Gregory, *The Intelligent Eye*, McGraw-Hill Book Co., New York, 1970. A remarkable and fascinating book filled with references to visual illusions, some in three dimensions.

Hermann von Helmholtz, *Treatise on Physiological Optics*, English edition, Dover Publications, New York, 1962. He was a world authority on vision and visual perception. The text is highly scientific.

Robert L. Herbert, *Neo-Impressionism*, D. Van Nostrand Co., Princeton, 1968. A beautifully illustrated treatise on this unique school of color in art.

Ewald Hering, *Outline of a Theory of the Light Sense*, English edition, Harvard University Press, Cambridge, Mass., 1964. He made important and original contributions to color vision, color order, and color perception (1878).

Wassily Kandinsky, *The Art of Spiritual Harmony*, Houghton Mifflin Co., Boston, 1914. A unique treatise by an originator and leader of abstract art, with personal views on color meanings.

David Katz, *Gestalt Psychology*, Ronald Press, New York, 1950. A short, clear, and original discussion of the subject, with emphasis on color perception.

David Katz, *The World of Colour*, Kegan Paul, Trench, Trubner & Co., London, 1935. A true masterwork on the Gestalt aspects of vision and perception.

Paul Klee, *The Thinking Eye*, George Wittenborn, New York, 1961. He taught at the Bauhaus and had one of the best "eyes" for color of modern painters.

Kurt Koffka, *Principles of Gestalt Psychology*, Harcourt, Brace & Co., 1935. One of the very best works in the English language on the subject. Difficult reading, but amply rewarding.

Wolfgang Köhler, *Gestalt Psychology*, Liveright Publishing Corp., New York, 1947. He was a leader in Gestalt psychology and expressed original views on color perception.

Stanton Macdonald-Wright, *A Treatise on Color*, published by the author, Los Angeles, 1924. He led the Synchromist school of color, which placed primary emphasis on the spectrum.

Gerald M. Murch, *Visual and Auditory Perception*, Bobbs-Merrill Co., New York, 1973. A good review of the subject, with numerous illustrations of visual illusions.

René Parola, *Optical Art*, Van Nostrand Reinhold Company, New York, 1969, A well-illustrated work on the subject, excellent for teaching purposes.

John Rewald, *The History of Impressionism*, Museum of Modern Art, New York, 1946. A classic work on French Impressionism, indispensable in understanding the color principles of this great movement in art.

John Rewald, *Post-Impressionism*, Museum of Modern Art, New York, 1956. A companion work to Rewald's eminent work on Impressionism.

Ogden N. Rood, *Modern Chromatics*, with introduction and notes by Faber Birren, Van Nostrand Reinhold Co., New York, 1973. He was America's foremost authority on physiological optics. His work (1879) greatly influenced Neo-Impressionism.

J. J. Sheppard, Jr., *Human Color Perception*, Elsevier Publishing Co., New York, 1968. A good review of the subject.

James P. C. Southall, *Introduction to Physiological Optics*, Oxford University Press, New York, 1937. One of the very best texts ever written on the subject.

S. Tolansky, *Optical Illusions*, Macmillan Co., New York, 1964. A fairly good source of illustrations that influenced the Op Artist.

M. D. Vernon, *A Further Study of Visual Perception*, Cambridge University Press, London, 1954. Includes interesting notes on the visual and physiological effects of color.

M. D. Vernon, *The Psychology of Perception*, Penguin Books, 1966. A first-rate review of the subject.

Heinz Werner, *Comparative Psychology of Mental Development*, Follett Publishing Co., Chicago, 1948. Contains interesting notes on many visual phenomena.

THE MAJOR BOOKS OF FABER BIRREN

AS AUTHOR:

Color in Vision, 1928.

Color Dimension, 1934.

The Printer's Art of Color, 1934.

Functional Color, 1937.

The Wonderful Wonders of Red-Yellow-Blue, 1937.

Monument to Color, 1938.

The American Colorist, 1939, 1962.

Character Analysis Through Color, 1940.

The Story of Color, 1941.

Color Psychology and Color Therapy, 1950, 1972.

Your Color and Your Self, 1952.

New Horizons in Color, 1955.

Creative Color, 1961.
(German Edition, *Schöpferische Farbe*, 1971).

Color, Form and Space, 1961.

Color in Your World, 1962.

Color for Interiors, 1963.

Color—A Survey in Words and Pictures, 1963.

History of Color in Painting, 1965.

Principles of Color, 1969.

Light, Color and Environment, 1969.

AS EDITOR:

The Natural System of Colours, Moses Harris (1766?), 1963.

Hints to Young Painters, Thomas Sully (1873), 1965.

The Principles of Harmony and Contrast of Colors, M. Chevreul (1839), 1967.

The Principles of Light and Color, Edwin D. Babbitt (1878), 1967.

The Color Primer, Wilhelm Ostwald (1916), 1969.

A Grammar of Color, Albert H. Munsell (1921), 1969.

The Art of Light and Color, Tom Douglas Jones, 1972.

Modern Chromatics, Ogden N. Rood (1879), 1973.

INDEX

COVER COLOR STUDY
PIGMENT INTO LIGHT

The artist is freed of the limitations
of his materials—through the magic
of perception.

COLOR STUDY I
FULL SPECTRUM, OPTICAL
MIX

In tribute to Georges Seurat, who
sought vibrant effects like this in a
divisionist technique.

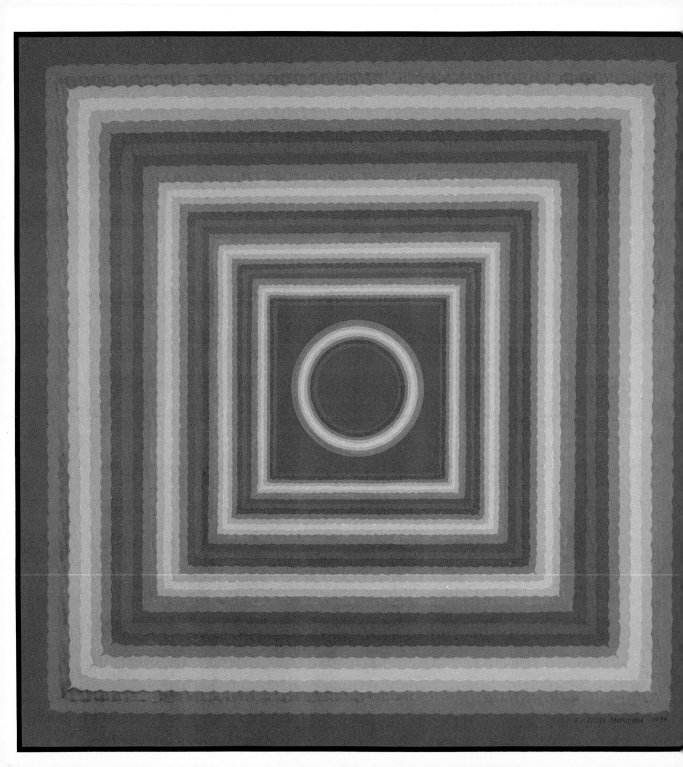

FABER BIRREN 1974

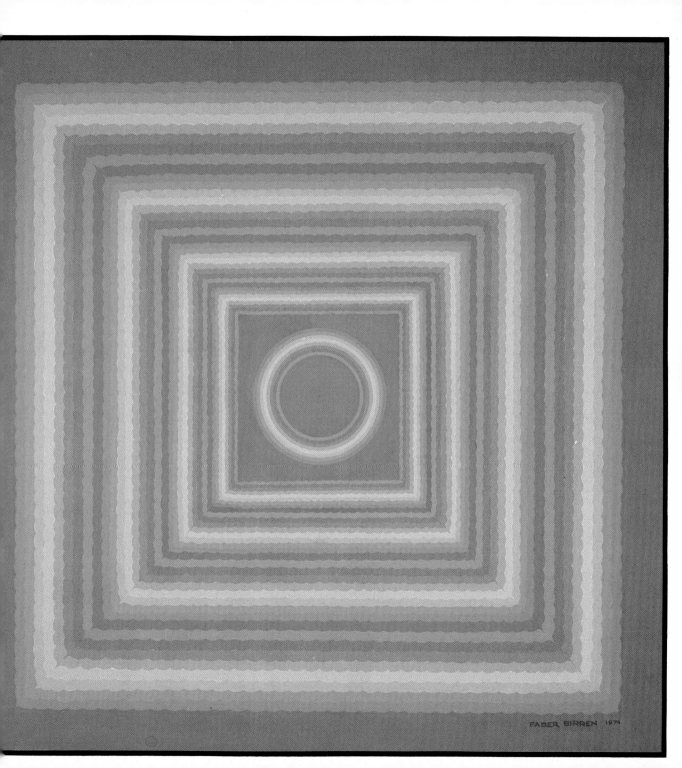

FABER BIRREN 1974

COLOR STUDY II
REFINED SPECTRUM, OPTICAL
MIX

In tribute to J. M. W. Turner, who
discovered the secrets of luminous
beauty in nature.

COLOR STUDY III
BRIGHT LUSTER

Sharpness of contrast makes colors
brighter than bright to human
perception.

FABER BIRREN 1974

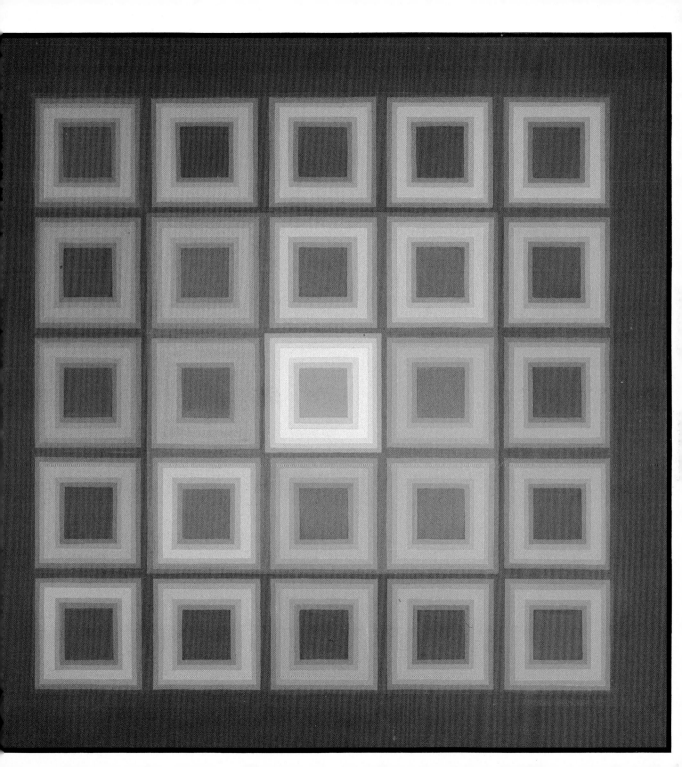

COLOR STUDY IV
MODEST IRIDESCENCE

The attempt is to convey the
shimmering beauty of an opal.

COLOR STUDY V
A SENSE OF ILLUMINATION

The spectrum in full light, in mist,
lighted from within, and under dim
light.

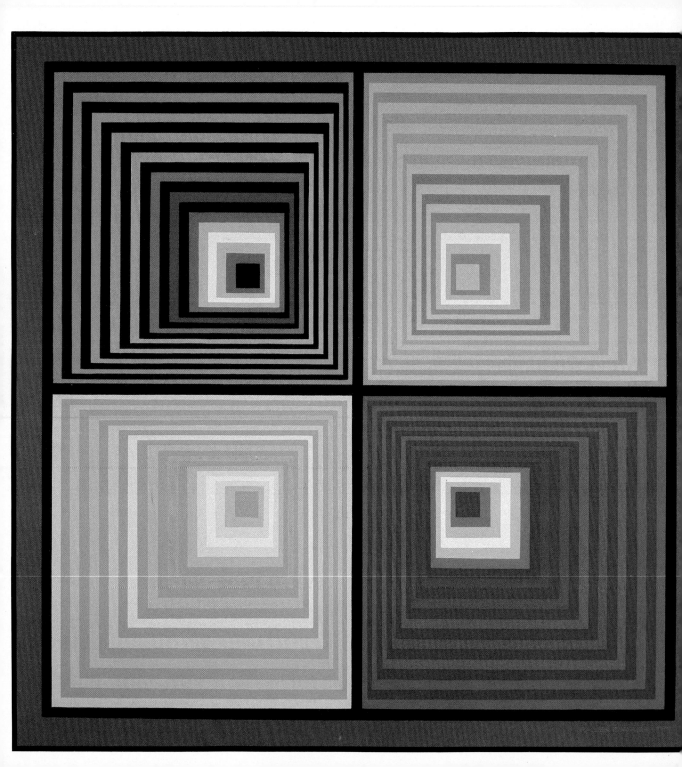

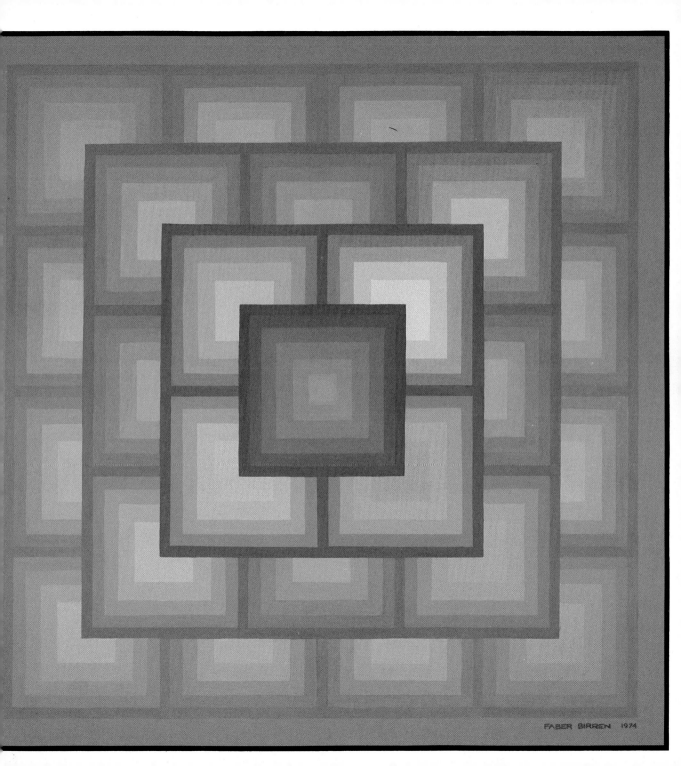

FABER BIRREN 1974

COLOR STUDY VI
LUMINOSITY IN A BLUE FIELD

Colors shine through the subtle
influence of muted gradations.

COLOR STUDY VII
LUMINOSITY IN A VIOLET
FIELD

With the outer tones suppressed,
the inner pure hues light up as if
from within.

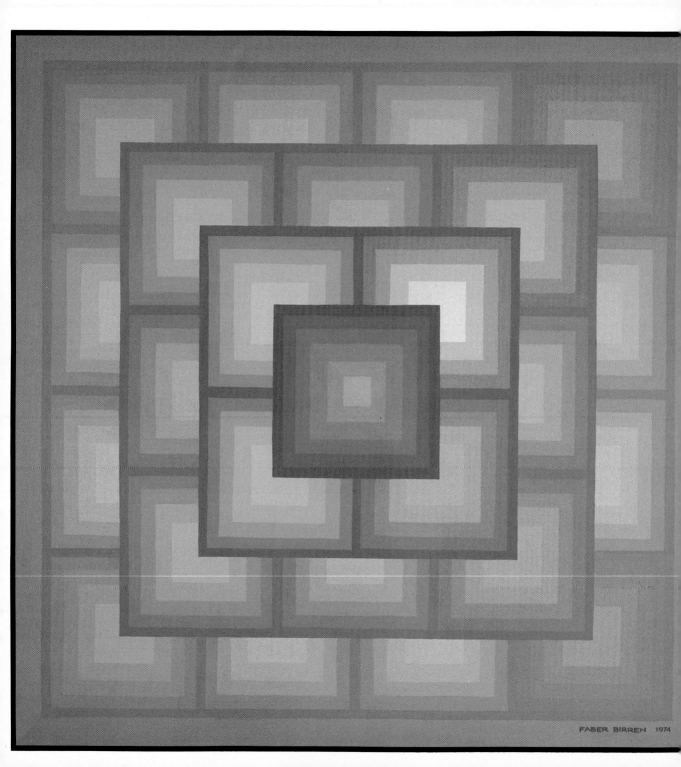

FABER BIRREN 1974

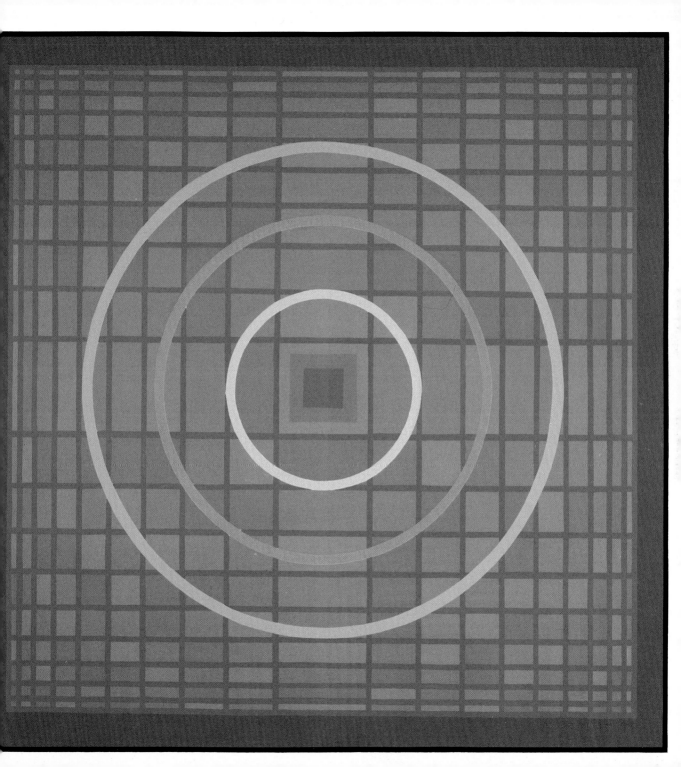

COLOR STUDY VIII
THE WETNESS OF A POOL

The bright rings could be advancing
through an underwater domain of
turquoise blue.

COLOR STUDY IX
THE DRYNESS OF A DESERT

In tribute to Vincent van Gogh,
who was fascinated by eerie yellow-
greens.

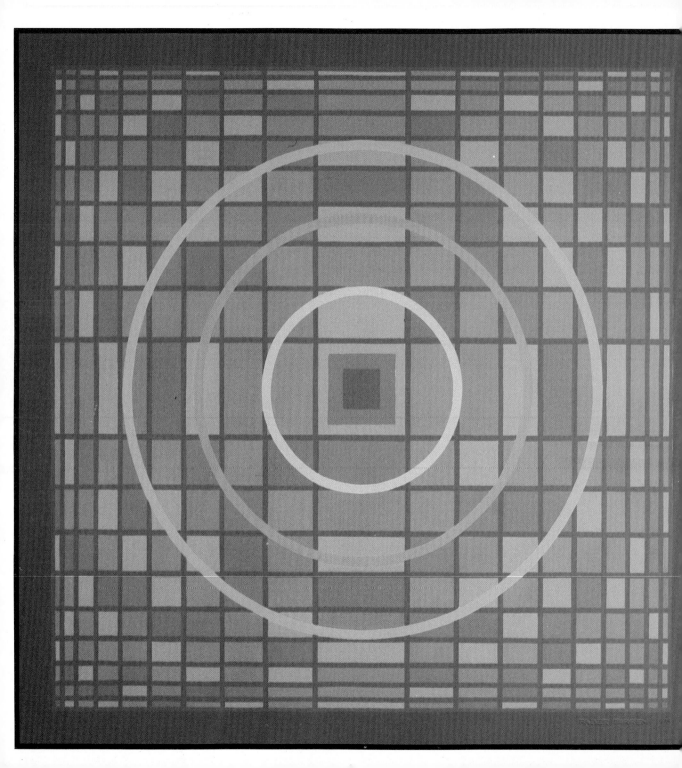

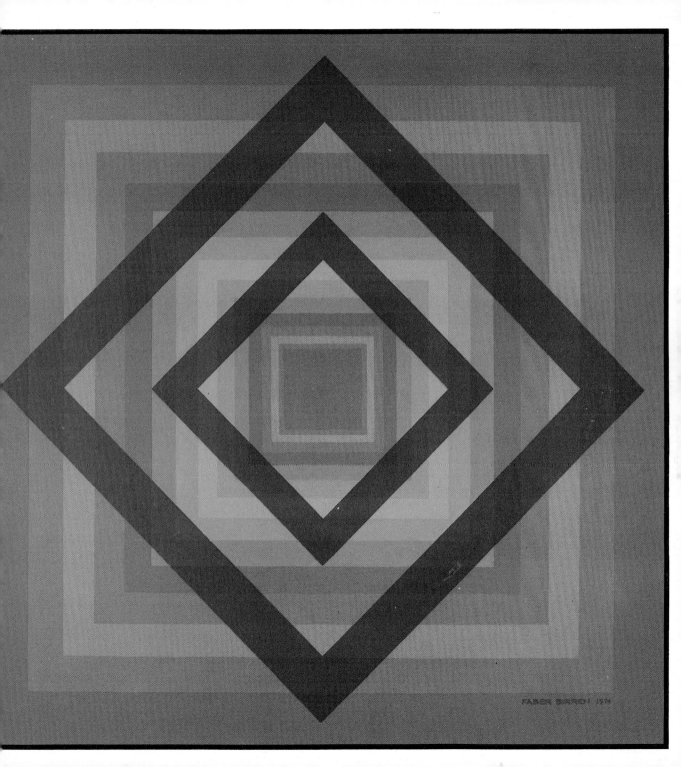

COLOR STUDY X
TRANSPARENT RED

Perception sees as transparent that
which is fully opaque.

COLOR STUDY XI
TRANSPARENT GREEN

There is an illusion of looking
through at colors underneath.

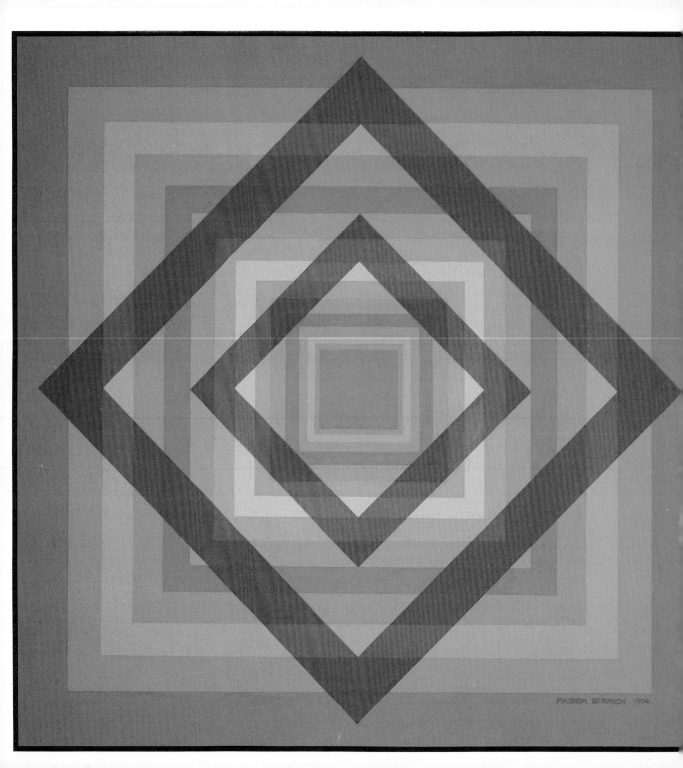
FABER BIRREN 1974

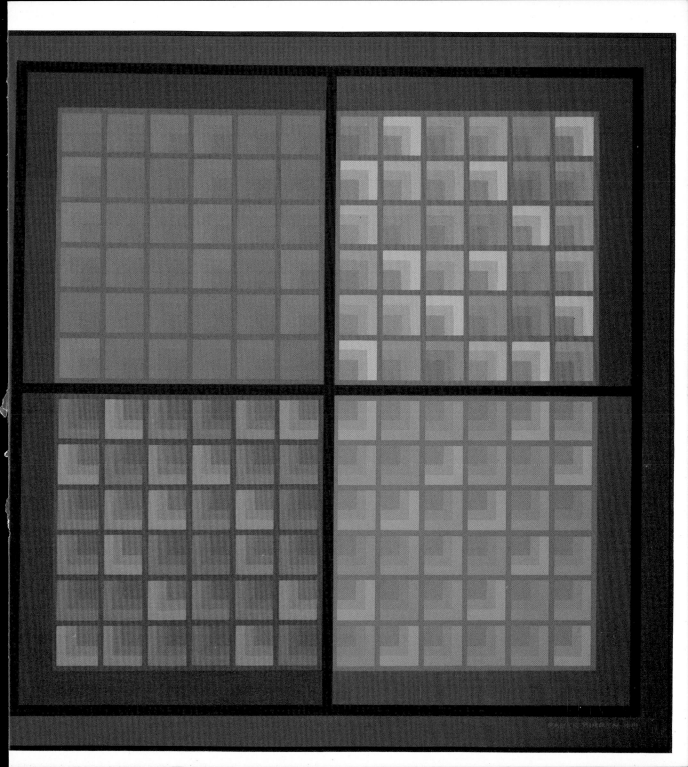

COLOR STUDY XII
CHROMATIC LIGHT

The effect is of normal colors
modified by tinted light.